Some Thoughts

Christina Hua

Ordering Information:

For orders and inquiries, please contact:
1-888-404-1388
www.goldtouchpress.com
book.orders@goldtouchpress.com

Printed in the United States of America

Contents

Cooking

Back when my sister and I were younger, all we wanted to do was eat. We would sit for hours in my grandma's hot living room in China waiting for my grandma to finish making dinner so we can chow down whatever food she placed in front of us. Because our grandma is from the southern part of China, she is a very talented cook and has a gift for using spices to her advantage. Even though she was able to create many different delicious dishes, our all time favorite dish is my grandma's braised pork. She could make a cauldron full and we would still be able to eat all of it. Because of its slightly sweet taste and tenderness, it quickly became our favorite food from the first time we ate it.

Now that we don't see our grandma so often, we aren't able to eat our favorite food so much. Fortunately for us, our dad learned how to make it from his mother years ago, so we are still able to eat some from time to time. Here's are the ingredients and recipe:

Ingredients*:

1. 1-1.5 lbs of pork belly
2. Ginger (to your taste)
3. Green onion (to your taste)
4. 1-4 hard boiled eggs
5. ½ cup of bamboo shoots
6. 1 tbsp sugar
7. 2 tbsp light soy sauce
8. 1 tbsp dark soy sauce(for color)
9. 1 tbsp vinegar
10. 1 tbsp cooking wine
11. 2 tbsp ABC soy sauce

*can change to whatever fits your taste

Steps:

1. Put cold water in pot. Pork, cut into dice. Put into cold water. Boil. Clean all the blood that comes out. When no more blood comes out, take out the pork. Clean under running water. Use the remaining hot water to boil the bamboo shoot. Take out bamboo shoot, use the remaining hot water to boil eggs.
2. Prepare for the sugar: heat the oil. put in sugar (just about 1 tablespoon sugar), and stir fry into syrup.
3. Add ginger and green onion into pot to stir fry the pork.
4. Add a peeled hard boiled egg.
5. Add light soy sauce, dark soy sauce(for color), vinegar, cooking wine, ABC soy sauce.
6. Boil on high heat, then turn to low heat for one hour.

Familial Roles

Before the Neolithic Revolution, men and women took equal parts in hunting and gathering in order to feed themselves and their families. However, after the Neolithic Revolution, women have been placed in the house to care for children and to cook, while men spent their time outside farming and doing heavy lifting. Because of the division between tasks, cooking, cleaning, and generally being a functioning adult became a standard for femininity. Since women had always been looked down upon by the patriarchy, men who cook became seen as feminine.

Society generally sees women who don't know how to cook as a 'bad woman'. Since girls are raised to eventually take care of their family, a girl who didn't cook was seen as inept. Although this mindset is changing, some people still expect all women to be great cooks even though in many families and restaurants men are the chefs. However, some people will enjoy the chef's food but see them as weak and not masculine. In America, many people end certain jokes with, "...and I said, 'Go make me a sandwich!'", referring how they still believe that women should stay in the kitchen. However, when said to a man, the person telling the other man to make a sandwich is saying that the man who cooks is becoming a woman.

However, cooking is something everyone should learn to do. Whether you have someone who cooks for you or if you live alone, cooking is a basic task that people need to do to stay alive. Both men and women who don't know how to cook should learn, as they can't be dependent on someone else to cook for them forever. For example, although my grandma cooks most of the time, my dad is also an accomplished home chef who is capable of feeding himself and his family. On the other hand, my mom used to never cook, but when both my dad and grandma went back to China, she realized that cooking was essential and began to learn.

Basically, after the hunting and gathering period ended, women ended up in the kitchen, which became seen as their 'territory'. After a patriarchal society was implemented, women were expected to cook, even if some men are better at it. However, the men who can cook are looked down upon for being feminine even though cooking is a survival skill and not something that defines masculinity or femininity.

Vaccinations

Ever since the invention of vaccines, there has been groups of people disagreeing with it. Nowadays, they are pop up mainly in Facebook groups, telling people about how vaccines cause autism and how we should all believe in the power of healing crystals, essential oils, and weed. However, they always seem to far away from us to worry about, we're behind a computer screen, therefore they cannot reach us. Well, now they have.

Starting on March 16, an unnamed international traveller arrived in Santa Clara County, infected with measles. Slipping past customs, the traveller went on to visit more than twenty places in the county, leaving trails bacteria behind them. Averaging about 3 places a day, the visitor hit an Apple Store, Stanford Hoover Tower, and multiple restaurants, grocery stores, and drugstores. However, these are just a general list of places they visited. The visitor truly took time to visit as many places as possible, spanning the cities of Sunnyvale, San Jose, Cupertino, Stanford, Palo Alto, Mountain View, Santa Clara, and Milpitas.

Although it may be easy to blame the traveller for spreading measles throughout the county, they aren't completely to blame. Had the infected citizens gotten their recommended vaccines, this would be less of a problem. Even if vaccines can't prevent 100% of all diseases, it would be way less of a risk for the citizens had they gotten their vaccines.

Biodegradability

Invented in 1907, plastic has been the source of many environmental debates, ranging from pollution concerns to biodegradability. Problems such as the usage of plastic straws and littering of soda rings are particularly mainstream as it endangers and kills sea creatures. However, littering, plastic waste, and mass production aren't the only problems with plastic.

As mass produced clothes became easier and cheaper to acquire, people began to search for less expensive options to produce it. The result of that is synthetic fabric. These clothes are basically made of thin plastic threads. Unfortunately, the problem with synthetic fabrics is that as you wash them, tiny plastic bits are washed out, and they are too small to be cleaned up. However, due to the durability, stretchiness, and inexpensive pricing, synthetic fabric became very popular, furthering the plastic problem.

Microplastic pollution is the result of these synthetic fabrics. The plastic parts the clothing that wash off are almost impossible to clean up due to their size. Currently, there are four solutions to microplastic pollution: biological degradation, adsorption, physical thermal techniques, and membrane separation.

Freshwater

Almost a decade ago, Hurricane Katrina hit the Gulf of Mexico, leaving a trail of destruction in its wake. Unfortunately, now, it seems as though the Gulf is facing more trouble.

Due to the rainfall this year, polluted water all the way up from Canada and other states, such as Wisconsin, Iowa, and Illiois is slowly making its way down into the Gulf of Mexico. This runoff is causing problems for the ecosystems of the Gulf of Mexico, killing the oysters, crabs, shrimp, and other marine life. As the waters of the Gulf of Mexico is saltwater, the polluted freshwater coming down from Canada is extremely harmful to the ecosystems down near Louisiana. According to HuffPost, shrimp catches are in the area are already down by almost 80%, and in some fisheries, oysters are completely wiped out. Furthermore, due to the freshwater brought down from rivers and rain, algae has begun to grow, leading to beaches closing in Mississippi. However, algae isn't the only damage caused by freshwater. Dolphins have been found dead in masses with skin lesions due to freshwater exposure.

Though many fisheries requested federal assistance, there is little hope of the aid reaching them in time. They suspect that the government has been purposely pumping in freshwater to rebuild land lost from Louisiana's sinking coastline, therefore ignoring the death of oysters, crab, shrimp, and dolphins caused by the freshwater in the Gulf of Mexico.

However, farmers have been combating this by planting crops that soak up excess water on off seasons. Both Illinois and Iowa have begun to plant cover crops, such as cereal rye, to contain the remainder water and nutrients. By doing this, they can prevent some of the freshwater from reaching the Gulf of Mexico and killing the marine life there. People must continue to contribute to this effort, or else disastrous consequences may ensue.

California Beaches

California is known for its beaches up and down it's coast, many of which retain their warm waters year round. Unfortunately for the mussels in Bodega Bay, the heat isn't something to be happy about. Due to the recent heatwave, the waters in Bodega Bay have reached up to 100° F, cooking the mussels in their shells. People have been finding mussels along the rocks with their mouths open and insides completely cooked.

Mussels are an important factor in the aquatic ecosystem, acting as a shelter for many animals. The sudden death of a vast population of mussels is impacting nearby marine life, since mussels are a foundational species, which means they have a strong role in structuring an ecological community.

Unfortunately for other marine life in Bodega Bay, the death of mussels isn't the main problem. The death of mussels are only a side effect of the sudden rise of water temperatures. Because of the warmer waters, shellfish are breaking, kelp and coral are dying, and starfish are melting.

There was another recorded event of a heat wave disaster happening back in 2004, but scientists seem to all agree that this case is far more severe than the one before. Since this kind of heat wave isn't a very common occurrence, scientists are still trying to figure out how to record enough data. Contributing to the effort, ecologist Brian Helmuth from Northeastern University designed a robot mussel that could measure and log temperatures that an animal might feel during severe climate changes.

Though this is another case of 'death by climate change', it seems that people are starting to give up on the idea of being able to revert climate change, and instead are beginning to think of ways to prepare for it.

India's Tiger Population

Humans and animals have been conflicting since the beginning of time, but as time went on, humans developed better weapons and animal populations began to drop. However, due to the multiple endangered species around the world, people began to protect animals rather than to fight them. Animal protection laws have been put in place along with sanctuaries and wildlife preservation acts.

In India, there is a large population of tigers, which causes multiple conflicts each day. Though Bengal tigers are an endangered species, the citizens of India sometimes are forced to kill the tigers in self defense. For the last two years, a tigress had been terrorizing central India, killing about thirteen people. Last fall, the people responded by trying to tranquilize her, but ended up shooting and killing her. Similarly, a tiger from a reserve near New Delhi attacked several people, and was beaten to death by a group of villagers.

Despite the human-tiger conflicts in India, the number of Bengal tigers has been on the rise. In 2018, the number of Bengal tigers rose by almost three thousand, moving the number of Bengal tigers in the world to about four thousand. The number of tigers are growing all across India, concentrated around Madhya Pradesh, where there are almost five hundred Bengal tigers.

Valmik Thapar, an Indian naturalist, credited the growth of the Bengal tiger population to the cooperation between state governments and wildlife officials. However, there is still a long way to go before the tigers could be safe. Valmik Thapar says that India has the potential to become a great wildlife tourist destination, but they have not yet realized that.

Unfortunately, in Eastern India, some places are still losing tigers despite the government's attempts to fund and protect them. In certain wildlife reserves, there are no tigers at all.

Amazon Fires

Burning lands is a tactic often used by farmers to clear the land, get rich nutrients in the soil, and restart their planting. Though risky, most of the time it pays off, leaving farmers with good land to work with. Sadly, this is not the case for the Amazon rainforest. Since we are currently in the Amazon's dry season, the fires spread faster than ever, causing up to four thousand outbreaks of fire.

The Amazon rainforest is a valuable ecosystem, providing us with medicinal plants that fight against tropical diseases, gold, silver, copper, tin, and zinc, coffee, chocolate, rice, potatoes, tomatoes, black pepper, bananas, pineapples, and corn. Not only does the Amazon provide us with these resources, it also makes up twenty percent of the world's fresh water supply and twenty percent of all of the world's oxygen.

On the thirty-first of August, the government banned burning lands in order to prevent the spread of more fires. Unfortunately more the Amazon, the ban of burning did almost nothing, as two thousand more fire outbreaks happened in the Amazon region within the next forty-eight hours. Not only were there more fires in the Amazon region, almost two thousand more fires appeared near the Amazon in neighboring regions.

Though the government has banned burning new lands, most people see it as a political stance rather than a useful one. Many see it as too late to do anything big anymore, and the ban on burning hasn't done anything to prevent more fires, as shown by the numbers above. Weather experts have already stated that rain won't be able to put out the fire for weeks. For now, there isn't much anyone can do to save the Amazon from burning down.

Veganism

When asked on how they can help the environment, most people reply with something along the lines of "buy an electric car", "eat organic food", or "save water and reduce usage of electricity". However, scientists say the best way to help the environment so far is veganism.

Veganism is a lifestyle, where one doesn't consume any animal products. This includes meat, fish, honey, dairy, and gelatin. Most studies and journals show that though electric cars and organic food can help the environment, veganism is the way to go if you want to create a lasting impact. Although we only get 37% of our protein from animal products, livestock takes up 80% of our farmland. Not only do they take up a lot of space, they are also responsible for 60% of greenhouse gasses.

For more added perks, veganism also can also give you assorted health benefits. A large portion of Americans are affected by diabetes, which can easily be avoided if we cut down on red meats and sugar. The American Journal of Clinical Nutrition say, "Vegans tend to be thinner, have lower serum cholesterol, and lower blood pressure, reducing their risk of heart disease."

If science doesn't convince you that veganism can help you in the long run, going vegan is also proven to save you money. Studies show that giving up meat and moving on to a plant based diet can save you almost $750 per year.

However, veganism is extremely hard to adhere to. Some restaurants have low to zero vegan choices, and though there are replacement meats and dairy, it still won't be the same. Not only is it hard to transition from a non-vegan diet to a vegan one, people these days have a lot of dislike for vegans. This mainly stems from the actions of extreme vegans, people who scream "Meat is murder!" and generally, try to force their lifestyle on others.

Though there are downsides to veganism, the pros outweigh the cons, and generally going vegan is better for your health, wallet, and for the environment.

Tobacco as Detergent

From an early age, schools teach children about the dangers of drugs and reasons to not use them and get addicted. Tobacco is very dangerous to humans, killing seven million people per year. However, besides using it as a drug that can harm you, it can be used as a helpful agent in detergent. Not only is it a better alternative to smoking it, it is cheaper and easier for manufacturers.

To turn tobacco into a detergent, scientists inserted a bacterial gene into tobacco that makes an enzyme called Cel6A in the chloroplast. Cel6A's main job is to dissemble large compounds, which makes it extremely useful in detergents since it would be able to get out large stains.

The next step scientists took to test out the efficiency of Cel6A in tobacco was to see how well tobacco could grow outdoors. Up until then, they had been planting tobacco indoors, and wasn't sure how well it would take to the outdoors. Not only is the outdoors a potential problem, tobacco plants would have to deal with other factors, such as weather patterns, insects, and infections.

Fortunately, the tobacco plants exceeded expectations and did very well, producing more Cel6A than the researchers and scientists had predicted. However, the tobacco plants produced less protein than it had indoors in the greenhouses and growth chambers that they had originally been placed in.

Since this study worked out well and scientists could now efficiently produce Cel6A, scientists are now looking into standardizing and making the process quicker so they could produce more.

PFBTA

Carbon dioxide is the most well known greenhouse gas, and people have been discussing its harmful impact towards global warming for years. However, nobody seems to know about Perfluootributylamine, also called PFTBA, a greenhouse gas seven thousand more times more powerful than carbon dioxide.

PFTBA has been around since the mid- 20th century, and is mainly produced in electrical industries. It is currently the most radioactive molecule in the atmosphere, and has warmed the Earth much faster than carbon dioxide had in the past one hundred years.

Fortunately, despite the potential danger PFTBA poses towards the environment, it has fairly low amounts in the atmosphere, which means it wouldn't have as big as impact as it could have. It's impact still doesn't compete with the issues caused by burning fossil fuels, such as oil and coal, which is the leading cause of global warming and climate change.

As there is now a risk of PFTBA causing a big impact on climate change, researchers push for people to be more careful about long lasting results and make sure that PFTBA's numbers don't grow and become a deadlier contributor to climate change.

Unfortunately, though PFTBA isn't creating a huge impact at the moment, it isn't a gas that is easily removed from the atmosphere. It isn't capable of breaking down naturally, and can remain in the atmosphere for up to five hundred years, and may take even longer to break down. We have remain wary of all factors of climate change, and PFTBA may become a pressing issue as time goes on.

Oslo's Car Free Dowtown

As a way to fight against climate change, Oslo, the capital of Norway, has decided to eliminate almost all the cars in its downtown area. The city remodeled the section, removing all the parking spots and replacing them with bike lanes, parks, plants, and benches.

Since one of their main goals is to improve air quality, Oslo has removed nearly all the cars except for delivery trucks and emergency cars. However, there are stricter rules for these vehicles as well—delivery trucks are only allowed early in the morning, while emergency cars are allowed throughout the day. Oslo also did not remove their parking garages, as that would be difficult with the amount of people who own cars. Also, the parking garages' main job is to reduce street parking, as not only would it make Oslo's downtown more aesthetically pleasing, but it would also be easier for pedestrians and bikers to venture around town.

Currently, Oslo is pushing for walking, biking, trams, and metros as other ways of transportation instead of cars. Public transportation would make the environment cleaner and day to day life more efficient. This way, rather than taking one vehicle per person, the residents could save a lot of traffic time by utilizing public transportation.

Though Oslo's car-free downtown is good for the environment, local business owners dislike the new policy. At first, the business owners believed that removing almost all the cars would create a 'ghost town' where nobody would want to visit. However, not only have the businesses retained their regular customers, tourism has even increased. People are fascinated by the carless environment Oslo's downtown has created, and has tourism spiked almost ten percent since.

Following Oslo's example, European cities such as Madrid, are following in their footsteps and slowly removing cars from their busy downtown areas.

About the Author

Christina Hua is a high school senior in San Jose, California. She enjoys playing with her cats and hanging out with her friends. In her spare time, she likes to do art and watch Friends or The Office.

About the Book

Some Thoughts is a compilation of the articles and writings I've done in the past. There are pieces on familial roles, recipes, and environmental issues.

Lightning Source UK Ltd.
Milton Keynes UK
UKHW050647120720
366320UK00002BA/32

9 781952 155550